⟨THE⟩
BOTANICAL GARDENS
OF WESTERN FLORIDA
THROUGH TIME

ANN MARIE O'PHELAN

AMERICA
THROUGH TIME®
ADDING COLOR TO AMERICAN HISTORY

Dedicated with all my love to my two boys,
Justin and Christian

AMERICA THROUGH TIME is an imprint of Fonthill Media LLC

Fonthill Media LLC
www.fonthillmedia.com
office@fonthillmedia.com

First published 2015

Copyright © Ann Marie O'Phelan 2015

ISBN 978-1-63500-019-1

Typeset in Mrs Eaves XL Serif Narrow
Printed and bound in England

Connect with us:
 www.twitter.com/usathroughtime
 www.facebook.com/AmericaThroughTime

AMERICA THROUGH TIME® is a registered trademark of Fonthill Media LLC

HISTORY OF
BOTANICAL GARDENS

G ardens have been around for thousands of years. In fact, ancient Egyptians planted lush gardens around their temples that were made up of trees, often planted in rows, such as sycamore figs, willows, pomegranates and nut trees. Another early civilization known for their gardening were the Romans who used plants for food and medicinal purposes, as well as for symbolism and celebration to their gods. The gardens were planted next to their palaces and villas, and featured statues and sculptures.

In the 8th century, monks planted monastic gardens, and used the plants for medicinal purposes. During the sixteenth and seventeenth centuries—a period of the Italian Renaissance—physic gardens, concentrating on the medicinal benefits of plants began to appear.

By the late eighteenth century, botanic gardens were first established in the tropics, although they were first created to receive and cultivate commercial crops, rather than assist with scientific studies. During this same period, economic botany, or the interaction of people with plants, was studied at the Royal Botanic Gardens, Kew, near London. The Royal Garden was founded in 1759, and continues to work in order to increase the understanding of plants and fungus and their many benefits to mankind.

Nowadays, botanic gardens are designed to inform the public about environmental issues and the impact of plants on the planet. They serve as learning centers and are key to the conservation of plants, many of which are threatened species. They also carry out documentation, labeling and monitoring of collections, the exchange of seed or other materials with other botanic gardens and institutions, and they typically conduct research and maintain records. Botanic gardens are open to the public and are often connected to universities or scientific organizations. There are approximately 2,500

botanic gardens in the world, and about 200 in the United States. The first botanic garden in continuous operation in the United States of America was the Missouri Botanic Garden, established in 1859. The seventy-nine acre garden is still in operation and is now a historical landmark.

The United States has a botanic garden all its own. The US Botanic Garden has collections dating to the 1840s, when 250 plants and propagation material gathered by the Wilkes Exploring Expedition (1838-1842) were brought back to Washington. The garden was envisioned by George Washington and established by the US Congress in 1820, making it one of the oldest botanic gardens in North America. The garden features a conservatory, with jungle, desert and primeval sections; the National Garden, featuring Mid-Atlantic plants; and Bartholdi Park, a two-acre park with unique plant combinations in a variety of styles and design themes.

During this book, a few of the notable botanic gardens in the State of Florida will be explored to see how they began, how they are evolving and what they may continue to grow into. The integral role they play in helping educate the public and preserving the environment will be better understood in order to bring public awareness to the role of these magnificent and important botanic gardens.

THE FLORIDA BOTANICAL GARDENS

ESTABLISHED AS A BOTANICAL GARDEN IN 2000

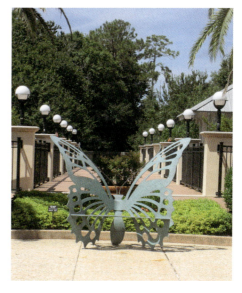

In 1999, the Florida Botanical Gardens, a Pinellas County Government Park, transformed from concept to plans over the course of a nine month planning period. By 2000, much of the Eastside gardens were open to the public. By 2011, the picturesque Palm Garden was completed. Today, the Gardens feature over thirty acres of cultivated gardens and ninety acres of natural landscapes. There is a charming Patio Garden featuring a waterfall, gazebo, colorful flowers and foliage; a Tropical Fruit Garden with over a dozen varieties of bananas and plantains, along with citrus, mango, papaya, and other fruits; a Native Plants Garden with wildflowers, trees and shrubs, all designed for the home landscape; a Seasonal Plantings Display Area boasting colorful bedding plants; a Succulent Garden with a worldwide assortment displayed in a small space; a Butterfly Garden with sculptures, stepping stones and fluttering butterflies; and a Bromeliad Garden, featuring shade loving "air plants." There are also three formal gardens, including a walled Wedding Garden with mosaic tiles, a Tropical Walk creating a taste of the tropics, and a Tropical Courtyard with ceiling fans and a picnic area.

The Florida Botanical Gardens also offer two natural features—the Aquatic Habitat Demonstration Area, showing the importance of water to wildlife; and a natural area with over sixty acres devoted to the restoration of plants and animals. Over 150 types of birds, mammals, and reptiles have been reported on-site, including bald eagles, gopher tortoises and Sherman's fox squirrels. From the beginning, the non-profit Florida Botanical Gardens Foundation has helped create, sustain and grow the garden to become what it is today. Garden tours are available.

All photos in this chapter are courtesy of the Florida Botanical Gardens, unless otherwise noted.

AN OVERVIEW: Original plans called for a variety of botanical areas, including rose, palm, wedding, and scent gardens, as well as walking trails through wooded and wetland areas. This would allow visitors to gain an understanding about what the growing requirements are for the plants featured in each of the individual gardens. As is the case with most botanical gardens, there would also be an outdoor learning center so that visitors could learn as they enjoyed strolling through the stunning grounds. The vision has unfolded beautifully as everything looks trimmed and polished, from vegetation to walkways to courtyards to water features. The Gardens also blend and unify with the other cultural offerings, the Heritage Village and the Gulf Coast Museum of Art, located right in walking distance.

GOOD SIGNS: On December 2, 2000, the Florida Botanical Gardens first opened to the public. Thanks to the help of many volunteers who spent countless hours assisting, the weeds and existing vegetation were pulled and cleared on the property, making way for the new series of gardens to exist. Their efforts were a labor of love. Although there are still many volunteers, the Parks & Recreation Department are now the primary caretakers of the garden, along with the Pinellas County Master Gardeners. When visitors arrive, the Welcome Center is often their first stop on their list. The Welcome Center was designed to help visitors with questions and provide them with helpful guides like trail maps and self-guided tours, so that the amazing Florida Botanical Gardens can be experienced fully.

OVERTURNING THE EARTH: In 1997, Friends of the Florida Botanical Gardens took the county Board of Commissioners and county administration staff through the entire property to show off the original plans. Every day since then, the Florida Botanical Gardens Foundation has been on site, hard at work, keeping the garden growing and flourishing. The Parks & Conservation Resources Administration, and the Pinellas County Extension and Horticulture Information Center, are also found on site.

SETTING THE WALLS: Walls were originally erected to help define and separate the gardens, to add to the ambience, and to provide a perfect place for vertical planting. The Wedding Garden is marked by ornate black iron gates on the outside, while beyond the gates white is the predominant color. There are white flowers, a white gazebo, and white etched-in-stone romantic quotes—all designed to make the most important day of one's life the most memorable it can be, as well as to provide a perfect setting for pictures.

PREPARING THE PLAZA: The McKay Creek, which is located in west central Pinellas County and includes parts of the City of Largo, Seminole and the Town of Belleair Bluffs, was a concerning issue, due to the fact that the property is located in a drainage basin within a flood plain, and there were occasional floods. This problem was alleviated as the creek was reduced into a stream. Today, the stream, which is about 6.2 miles long (primary channel), adds an attractive element to the garden setting. Other water features are fountains that were added in order to enhance the natural sounds, and to attract butterflies, like the tiger swallowtail and birds, such as the roseate spoonbill.

PLANNING THE WEDDING: The Eastside Gardens were opened early on, and they include the Tropical Garden, the Palm Garden and the Wedding Garden, shown here as it is being planted and created. The Wedding Garden has four separate areas, set in each of the four corners. There is the Topiary Garden, featuring live plants that have been trimmed into a designed shape; the Jazz Garden, offering a contemporary arrangement of plants; the Rose Garden, featuring hybrid tea, climbing and other types of roses that flourish in Florida; and the Cottage Garden, with an assortment of plants that give a nod to the old-world style of gardening.

Courtesy of O'Phelan

GROWING ALONG: As time passed, the Rose Garden was filled with a variety of colorful roses that grow well in Florida's sub-tropical climate—a climate marked by hot, humid summers and mild winters. The white ceremonial gazebo set in the Wedding Garden is a popular spot for those saying their vows, and for those who enjoy the picturesque formal garden even when a wedding isn't taking place. Colorful mosaic artwork can also be found in the Wedding Garden and throughout the rest of individual gardens.

TRIMMING TOPIARY: The lively Topiary Garden was planted in one of four corners of the Wedding Garden. It features a cupid topiary surrounded by a circular pathway. There are also small animal-shaped topiaries, such as bears, birds and other creatures. Topiary, the art of trimming and training perennial shrubs or trees into unnatural ornamental shapes, dates back the Roman times; however, we still see it in many formal gardens and sometimes in front yards.

TROPICAL DELIGHTS: The Tropical Garden was first planted with date palms, tapioca, ginger and bromeliads. An archway was incorporated to formally mark the entrance, and an inviting pathway was added to allow visitors to meander through tropical vegetation and enjoy the fresh scent of the many tropical fruit trees. The Tropical Garden was also designed to be the perfect place to escape the heat and the rays of Florida's year-round sunshine. Since the Florida Botanical Gardens first opened, the Tropical Garden has filled in quite a bit; it's now cooler and shadier than ever, providing a welcome relief to visitors year-round.

COOLING OFF: The covered porches and arbors, along with the brick patio, were installed to add to the lush ambience of the Tropical Garden. Today, many of the plants in this garden, such as passionflower and honeysuckle, offer lovely tropical fragrances. It is the scents of these colorful flowers that help make the experience of the Tropical Garden a multi-sensory one.

Courtesy of O'Phelan

INVITING ENTRANCES: The garden entrances used to be less defined, but, as time passed, they are now filled in with shades of green, colorful vegetation and flowering plants. The separate gardens are each clearly marked with formal gates, signs and inviting walkways that lead the visitor from one garden to another flawlessly. Two hours is the recommended amount of time one needs to experience the Florida Botanical Gardens' many offerings.

Courtesy of O'Phelan

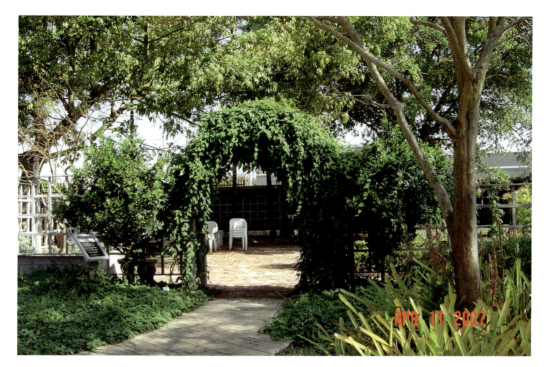

GOOD PLANS: Early plans for the Gardens came with the assistance of many experts, such as horticulturalists and plant societies. This careful planning would help ensure that the Gardens would develop as intended and would be prime examples of how to incorporate conservation measures, while remaining attractive and memorable. Nowadays, the Gardens are all that was originally envisioned and much more with many future plans in store.

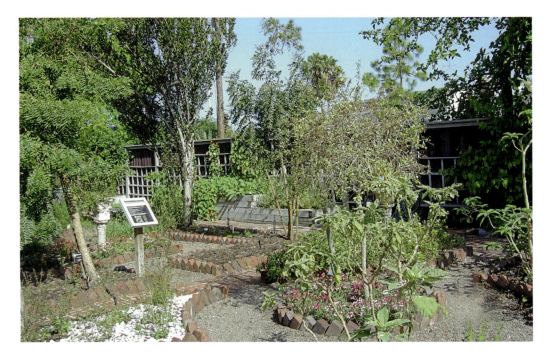

MARKED WELL: Since the original plantings, the many individual gardens set inside of the Florida Botanical Gardens have grown and so has the educational experience for visitors. There are now educational markers that explain to the visitor what they are viewing and experiencing. The purpose of these is to allow the visitors to gain a deeper appreciation of native Florida vegetation. The markers also uphold the mission of the Gardens of being a world-class educational and leisure resource. Many of the newer trees were paid for with funds from the Gardens' Tree Bank, created by the Florida Botanical Gardens Foundation.

Courtesy of O'Phelan

GARDEN SYMBOLS: While much of the original vegetation, the statues, and the points of interest still stand, the individual gardens and their unique elements keep evolving and growing. The statues and other features give distinction to each of the ten separate gardens. However, they all remain unified in other ways: through flowing water and streams, lovely fountains, lively colors, tactile textures, formal walls and splendid décor. The original plans called for individual gardens that blended together seamlessly, and this has proven to be successful.

19

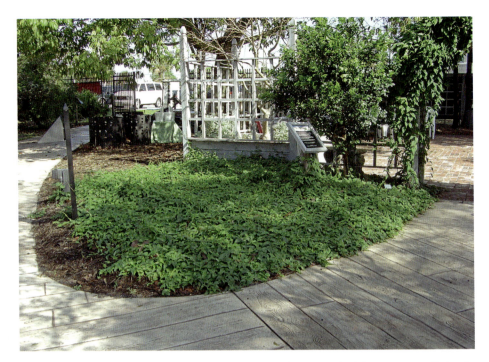

GARDENS DEFINED: The individual gardens were always marked, but are now all clearly distinct—thanks to the ongoing growth of the vegetation, and thanks to the prominent signs carefully added to each one, such as the sign marking the entrance to the Palm Garden. The Palm Garden offers a variety of palm trees, which are among the most economically important plants in the world as they are prime sources of vegetable oil and fat. The Palm Garden also offers visitors the perfect spot to enjoy a picnic lunch or a restful stop.

Courtesy of O'Phelan

INVITING VIEWS: Along with a lovely herb garden, there is also a cactus and succulent garden that features a variety of plants from around the world, such as barrel cactus, which are found in the deserts in Southwestern North America. Succulents are plants that have thicker and fleshier parts to help retain water. While the gardens always offered points of interest, including statues, potted plants and water features, they now offer a chance to see some elements, such as the Aquatic Habitat Demonstration Area, up a little closer—thanks to magnified viewers. A retention pond demonstrates how important water is to wildlife. The pond also helps filter runoff water before it flows into McKay Creek.

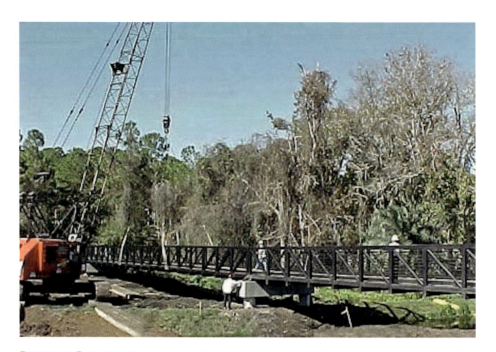

BUILDING BRIDGES: The Boardwalk Bridge, above the McKay Creek, is home to various wading birds such as herons and egrets, and box and softshell turtles. And it is also home to some of Florida's famous alligators. This bridge takes visitors from the parking lot to the Formal Gardens—Wedding Garden, Tropical Walk and the Tropical Courtyard. There are two other bridges in the gardens, including one that takes visitors to the Demonstration Gardens, where visitors have the opportunity to explore a wildlife haven with a retention pond. There's also a bridge that takes visitors from the parking lot to the Welcome Center. These bridges help unify the grounds and create one amazing botanical garden that can be enjoyed for generations to come.

Courtesy of O'Phelan

Marie Selby
Botanical Gardens

Established as a botanical garden in 1973

In the early 1900s, William and Marie Selby purchased seven acres of land bordering on the Sarasota Bay and the Hudson Bayou where they subsequently built a Spanish-style, two-story home. The landscaping was left to Marie, and she planted many flowers, along with a beautiful rose garden. Marie was a charter member of Sarasota's first garden club, the Founders Circle. She championed keeping Sarasota beautiful with flowers and greenery, and, in fact, planted bamboo by the bay in order to block her view of development across the bay. William Selby passed away on December 4, 1956, and Marie lived on the property until June 9, 1971. In her will, she designated her property to the community to use as a botanical garden. Upon Marie's death, a board of directors was appointed, who, after consulting with the New York Botanical Garden and the University of Florida, decided that the garden should specialize in epiphytic plants; they began efforts in earnest in 1973.

Today the garden has increased in size from seven acres to nearly fifteen acres. The living plant collection numbers more than 20,000 with thousands of plants,

flowers, trees and shrubs in the many outdoor gardens, including the Bonsai Garden and Fern Garden. The campus features the original Selby home, along with the Christy Payne Mansion that was purchased on the adjoining property, eight greenhouses counting the Tropical Conservatory (the only one open to the public), a Botany Department that is headquarters for the Bromeliad, Gesneriad, and Orchid Research Centers, and the Selby Gardens' Herbarium and Molecular Laboratory, as well as a gift shop. Guided tours are available.

All photos in this chapter are courtesy of Marie Selby Botanical Gardens, unless otherwise noted.

SWEETHEART SELBYS: Marie and Bill Selby were high school sweethearts. In 1908, they were married in Marietta, Ohio, and came to Sarasota the following year. Who would have thought a romance would have led to the world-renowned Marie Selby Botanical Gardens that more than 130,000 visitors enjoy annually?

THE IMPRESSIVE BAY: The Marie Selby Botanical Gardens is located on the southern edge of downtown Sarasota and is bordered on two sides by the Sarasota Bay and the Hudson Bayou. Although the landscaping has changed over time, the waters remain the same: a beautiful shade of blue. Sarasota Bay is the largest and deepest coastal bay between Tampa Bay and Charlotte Harbor.

STILL GREEN: An early aerial view of Sarasota Bay, located in Sarasota County, shows the wide, open spaces and greenery. The greenhouses, located on the property, provide a place to conduct research, manage collections, take inventory, classify, disseminate and conserve plant life. The Gardens specialize in epiphytes, including bromeliads and orchids. Epiphytes are plants that grow (non-parasitically) on others plants or trees. They derive their moisture and nutrients from the environment around them. The Gardens have an impressive collection of more than 6,000 orchids.

Image by Bob Wands Photography. Courtesy of Marie Selby Botanical Gardens

CASUAL LIVING: In the early 1920s, Marie and Bill Selby built a Spanish-style, two-story house nestled among the laurel and banyan trees. Although they had a lot of wealth—due to their investments in oil and mining—they lived rather modestly. Today, that same home welcomes visitors with a coffee shop to enjoy a breakfast or lunch. Indoor and outdoor seating is available.

Courtesy of O'Phelan

THE NEIGHBORS: The 1934 Christy Payne Mansion is a two-story house that overlooks Sarasota Bay. It was built for Christy Payne as his retirement home. His father, Calvin M. Payne, was a big name in the oil business. This home is a good example of Southern Colonial architecture. Purchased by Marie Selby Botanical Gardens in 1973, it now houses botanical art and photography exhibits, and provides facilities for meetings and special events. It is also on the National Register of Historic Places.

A BIT OF SHADE: A walkway with a wooden arbor was created to offer plenty of shade for the greenhouse, the plants in the walkway, and for the visitors entering. A lovely bonsai collection can be found underneath. The wooden arbor is located just outside of the doorway from the main entrance where one can find a gift shop and welcome center.

REST AND RELAXATION: Although the area offers some of the best fishing in the world, the Selbys weren't always relaxing with a fishing pole on one of their powerboats—all named "Bilma," a blend of the names Bill and Marie. The couple also enjoyed relaxing on their property and sipping afternoon tea, much like what is offered now at the Carriage House Tea Room, just steps from the entrance to the Christy Payne Mansion.

Courtesy of O'Phelan

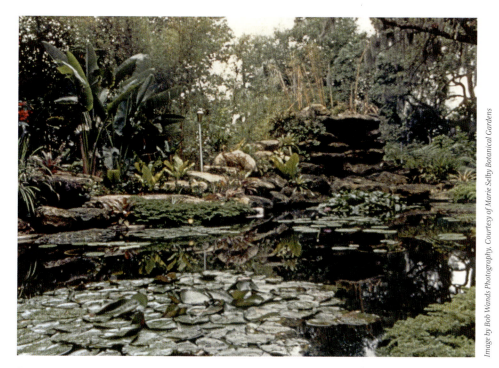

Image by Bob Wands Photography. Courtesy of Marie Selby Botanical Gardens

STOP AND REFLECT: The garden long offered a place to relax for the Selbys, who were known for their casual nature. The campus contains water features, such as a Koi pond for rest and reflection. A Buddha statue watches over the pond, while an inviting bench beckons visitors to sit for a moment. There is also a Japanese gong that children love to strike—once they are done feeding the brightly-colored fish, that is.

Courtesy of O'Phelan

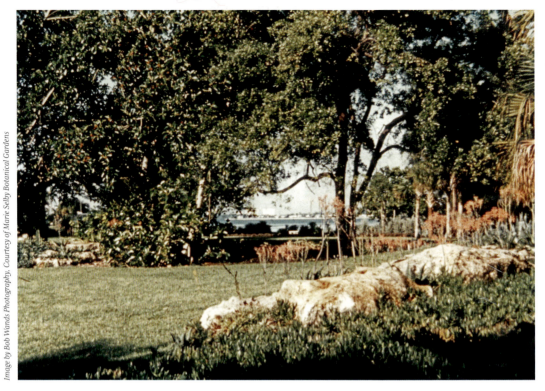

THE BAY AND THE BRIDGE: Sarasota Bay was something that the Selbys enjoyed often via boat, and it was also home to the Sarasota Yacht and Automobile Club, frequented by the couple. Today the bay offers views to the Ringling Bridge, named for John Ringling, founder of the Ringling Circus. The bridge connects Sarasota with St. Armands Circle, an island shopping center separated from the mainland. Underneath the bridge lies the beautiful twelve-acre Ringling Bridge Causeway Park, an urban oasis.

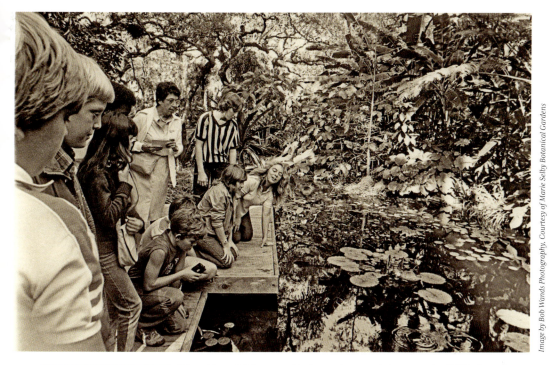

Image by Bob Wands Photography. Courtesy of Marie Selby Botanical Gardens

CHILDREN'S DELIGHTS: Educating children on the importance of plants and wildlife has always been part of the Gardens' mission. School programs, activities and classes for children are offered, along with the recently opened Ann Goldstein Children's Rainforest Garden, where a variety of outdoor adventures designed to allow children to explore, discover and play, are available.

Courtesy of O'Phelan

A MEETING PLACE: The beautiful grounds and facilities have always been a meeting place for societies, organizations and groups to gather. These days special events and weddings also take place in the picturesque setting.

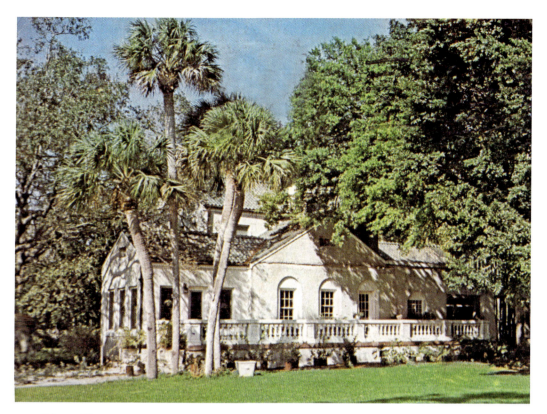

MANY HOMES: In addition to the Spanish-style, two-story house that the Selbys lived in, the Gardens now own several other area homes that are used for research, offices and archives. All told, there are nearly fifteen acres and twelve buildings on the property.

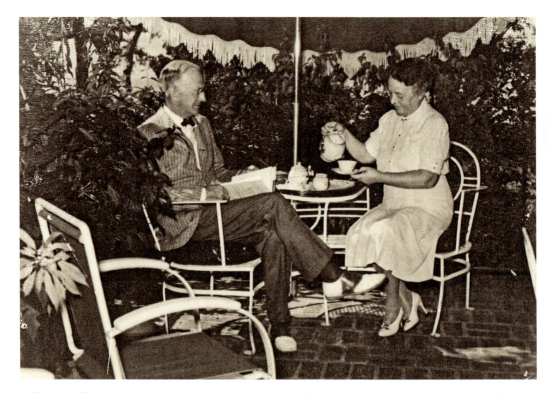

A Spot of Tea: Afternoon tea was part of the relaxed lifestyle enjoyed by the Selbys. It typically included a light meal along with a delicious cup of tea. Now, the same enjoyment can be had at the Carriage House Tea Room, where fluttering butterflies can also be observed in the Butterfly Garden, while scents of nearby fresh herbs linger in the air.

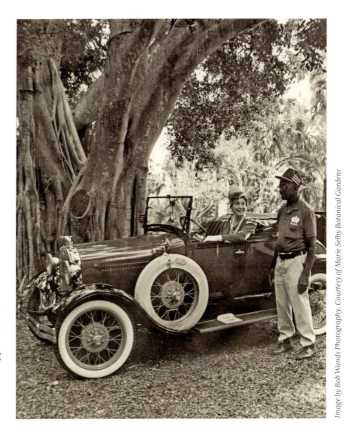

Image by Bob Wands Photography. Courtesy of Marie Selby Botanical Gardens

ROOMS WITH A VIEW:
Thanks to the many large windows, the Christy Payne Mansion offers beautiful views of the gardens and the Sarasota Bay. The circle driveway out front has long been a focal point, including during the Garden's fifteenth year anniversary celebration, where many memories were brought back to life.

Courtesy of O'Phelan

QUIET PLACES: When the Selbys first arrived in Sarasota there were fewer than 1,000 residents. By 2013, according to the US Census Bureau, the City of Sarasota had a population of 53,326. Even with the increase in population, and the many visitors, there are plenty of quiet areas to enjoy at the Gardens, including this one outside of the Christy Payne Mansion where a large oak tree stands tall.

SURROUNDED BY WATER: The Gardens are surrounded by the Sarasota Bay and the Hudson Bayou. Thanks to the mangrove walkways located near the shoreline, visitors can enjoy the beautiful blue waters as they walk. Mangroves are defined as trees and shrubs that grow in the coastal intertidal zone. These plants help trap and cycle a variety of organic materials, chemical elements, other important nutrients, as well as provide surfaces on which various marine organisms can attach.

A WEDDING DAY: Marie Selby was born Mariah Minshall in Wood County, West Virginia, on August 9, 1885. She married her high school sweetheart, Bill, in 1908. These days, other couples can enjoy their wedding celebration at the lovely Schimmel Wedding Pavilion, located on the south edge of the Great Lawn at Marie Selby Botanical Gardens. It's the ideal location for a picture perfect wedding.

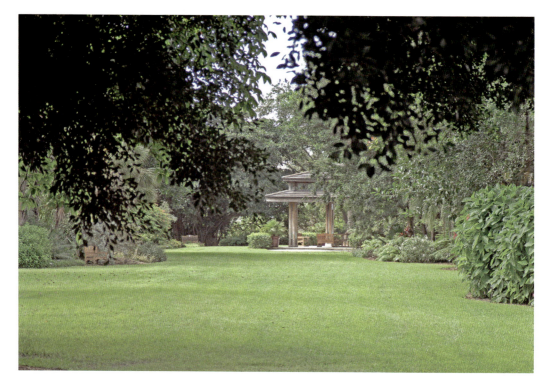

THE BOTANICAL GARDENS AT SANIBEL MOORINGS

ESTABLISHED AS A BOTANICAL GARDEN IN 2009

Although the Sanibel Moorings Resort in Sanibel Island Florida was built in 1974, the gardens that weave through the beautiful beachside resort's six-acres took time to become the wondrous attraction they are today. The first gardener was an avid botanist who created the gardens using diverse and unusual tropical plants. Over the years, all of the gardeners have left behind their own special contributions. Today, Head Gardener Anita Force Marshall offers a unique wildlife-friendly tropical botanical garden. Visitors enjoy native plants, non-invasive tropical species including collections of bromeliads, cacti, hibiscus, orchids, palms, fruits, and cycads. Butterflies, such as the zebra longwings, giant swallowtails, and long-tailed skippers abound amongst the brightly-colored flowers, while osprey, snowy egrets, brown pelicans and magnificent frigates are commonly seen overhead. Benches and water fountains add to the ambience and offer a time to reflect and enjoy the brilliance of this botanical garden.

Sanibel Moorings Resort is located on the Gulf of Mexico and therefore the opportunity to stroll to the beach and watch dolphins dipping, birds soaring and waves splashing adds to the experience.

Seashell lovers find plenty to garner on the shorelines, such as calico scallops, lightning whelks, banded tulips and sand dollars before they wind their way back to the pathways filled with foliage and flowers.

Guided tours, self-guided tours and private tours are available throughout the week, and provide a wealth of helpful information about plants, flowers, wildlife and good gardening practices.

All photos in this chapter are courtesy of The Botanical Gardens at Sanibel Moorings, unless otherwise noted.

EARLY DIGS: The Sanibel Moorings Resort in Sanibel Island, Florida was built in 1974. As time passed, the gardens were cultivated and added to by a succession of gardeners who fell in love with the wandering paths that weaved throughout the condominiums, located just a stone's throw from the sea. The original gardener started what was to become the botanical gardens of today, bursting with greenery and shades of bright colors.

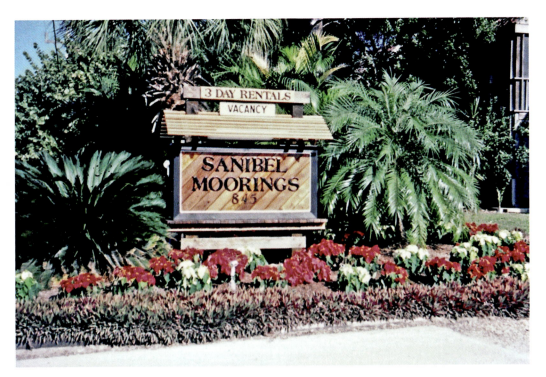

EARLY ENTRANCE: Since early on, the front entrance and the path from the front desk to the beach, have shown off a plethora of tropical and native plants. Native plants are those that have evolved over many years in a particular region. The plants in this garden grow well in the Southwest Florida region, USDA Zone 10Aa, a sub-tropic location that is between the tropical and temperate zone.

FRONT OFFICE: The multitude of red flowers near the front office of the Sanibel Moorings Resort were planted to attract hummingbirds and provide a fresh scent to visitors and guests. As time passed, water features were added to offer a soft ambient sound and to help attract other species of birds. The flowering pink and white periwinkles, shown here under the brilliant Chinese-Lantern tree, are common on Sanibel Island, as they provide bursts of bright color and grow well in the sun.

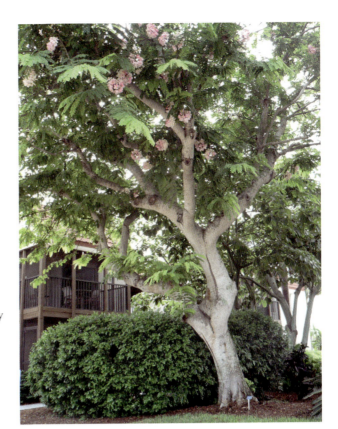

BLOSSOMING BEAUTY:
In just twenty years, the unique apple blossom cassia has made impressive growth. The tree features clusters of pink, dark rosy pink and cream-colored flowers. It also thrives in the full sun that is offered year-round on Sanibel Island. Many cities in Florida average over 200 days of days with sun per year, and Sanibel ranks high.

45

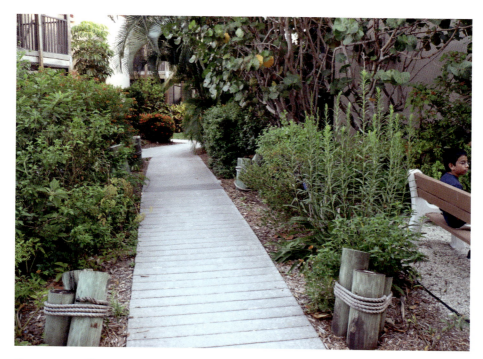

ATTRACTING BUTTERFLIES: The Butterfly Garden was slowly planted along the way. Today, it offers guests and visitors educational plaques, brochures and trail markers to help them identify the type of butterflies fluttering around. Butterflies enjoy nectar-rich flowers, especially red-colored ones, host plants and a sunny place to rest, such as on a rock. On any given day, one might see zebra longwings, gulf fritillaries, and long-tailed skippers. There are over 20,000 species of butterflies in the world and 575 in Southern United States.

BURST OF FLOWERS: In a sub-tropic climate, vegetation grows at a dramatic rate—thanks to the humidity, temperature and rainfall. Natural trimming and mowing are common tasks performed every week during the summer months. The pathways show the enormous rate of growth occurring, as well as the newer plantings added by Head Gardener, Anita Force Marshall, who also works to create a wildlife-friendly botanical garden that can be enjoyed by birds, rabbits, turtles and other small creatures..

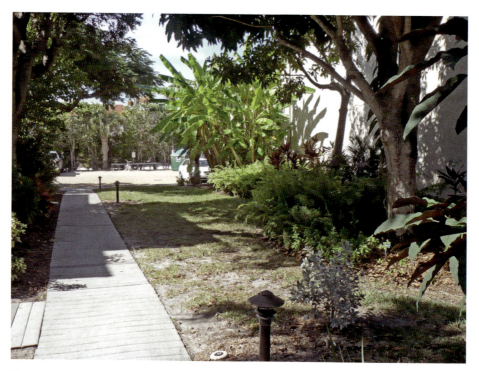

WALKING PATHS: As time progressed, the change in the gardens became more remarkable. What was barren, is now filled with vibrant vegetation and inviting sitting benches and chairs. These days, fresh flowers, such as the showy hibiscus in the far left foreground of the picture below, line the path. The flowers of the hibiscus are also edible, and are sometimes found in regional salads and dishes.

SMALL STREAMS: Due to their ability to enrich the habitats of animals and birds, along with the soft flowing ambience they offer an already calm setting, water features like this fountain have been added. Water features that used to be located in only a few areas of the garden, but can now be found throughout the Gardens, and make for a full spectrum of enjoyable sights, smells, tastes, touches and sounds.

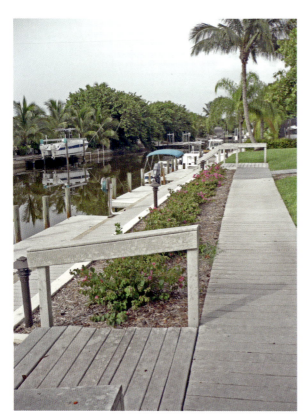

ON THE DOCKSIDE: The Sanibel Moorings Resort also has dockside condominiums. Way back when, they featured a path of flowers; however, now the docks offer sitting areas, colorful retaining walls, and a mix of gorgeous flowers that always attract many butterflies.

STRAIGHT WALKWAY: It's hard to believe that in just six short years, the pathways transformed into inviting garden areas that promise something new at every turn. Shown here are West Indies Mahogany trees that offer a canopy of shade for the comfort of guests and for the shade-loving plants underneath.

ROSE GARDEN: The Rose Garden was always lovely, but now offers a white arbor which many have snapped wedding and souvenir pictures underneath its arches. Also, the brick pathways and gorgeous princess palms help lead the way up to that special moment, while the backdrop is just as picturesque.

WANDERING WALKWAYS: Initially, the walkways only led to certain places, such as the office, the conference center and the exercise room. However, they now also lead guests to resting benches, scenic fountains and a place to put one's feet up along the way. Here we see an enchanted spot to enjoy the rising or setting sun.

THAT-A-WAY WALKWAY: The lush vegetation creates natural canopies that offer shade and the chance to wander underneath the trees. In the forefront of the picture below, we again see colorful periwinkles that thrive in tropical locations throughout Sanibel Island. Nearby lies the white sandy beaches that Sanibel is famous for.

HARD HIT: In 2004, Hurricane Charley blew across Southwest Florida. A Category 4, this was the strongest hurricane to hit Florida since Hurricane Andrew in 1992. Damage to the state totaled over thirteen billion dollars. Sanibel Moorings Resort was hit hard and lost many trees and vegetation that have since recovered or have been replanted.

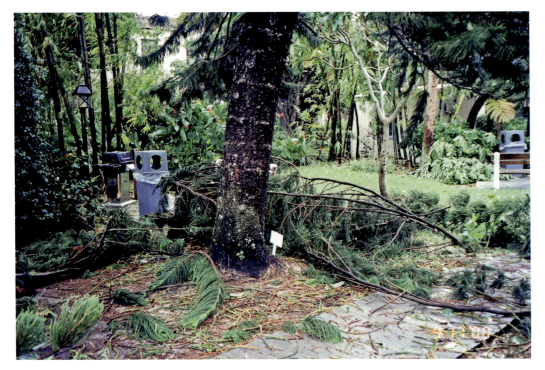

FALLEN TREES: Hurricane Charley devastated much of Sanibel Island, a barrier island with an east–west orientation. At its peak, the winds attained a 150-mph speed that, not surprisingly, knocked down trees, vegetation, homes and electricity. However, today it's hard to believe the locale ever suffered from such an immensely strong storm.

ON THE BEACH: Just beyond the entrance of the resort lies the Gulf of Mexico, which Sanibel visitors have long enjoyed. Shell lovers scout for calico scallops, lightning whelks, banded tulip shells and sand dollars on the white sandy beaches, while osprey, snowy egrets and brown pelicans fly overhead. A welcoming path leads down to the Gulf.

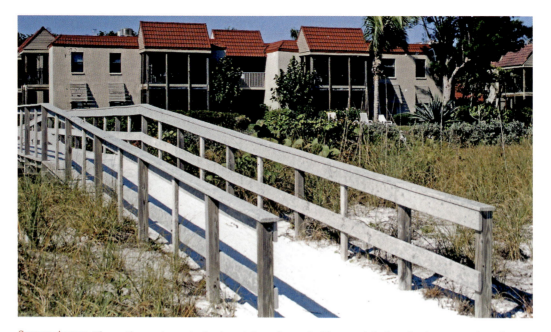

STEPS AWAY: The pathway down to the beach has always held a special place in the memories of those who come for a stay or a tour of the botanical gardens. The beach, just over the horizon, is world-renowned for finding shells, which the Gulf of Mexico brings right up to its shoreline. The "Sanibel Stoop" is what is referred to as those who stoop over with their shovels and buckets looking for those special treasures from the sea. Many paths ultimately lead down to the beautiful beach.

EDISON & FORD WINTER ESTATES

ESTABLISHED AS A BOTANICAL GARDEN IN 1947

In 1885, Thomas Edison's plans for his winter estate included areas for a research laboratory and family gardens, with a focus on practicality. Early on, Edison, Henry Ford and Harvey Firestone planted ficus trees in attempt to find a source of rubber (latex) that would to grow in the region.

Some of the giant ficus trees are still in existence today, including one that covers an acre. Also found is a giant banyan tree, planted around 1925, along with heritage plants, including sausage trees, mango trees, eucalyptus trees, kapok trees, tropical snowballs and the king's mantle. The Moonlight Garden, originally designed in 1929, by landscape architect Ellen Biddle Shipman, features stately palms planted in single file; a unique collection of cycads, prehistoric plants, more than a dozen varieties of bamboo, 1,700 plants representative of more than 400 species from six continents, along with fruit trees, orchids, and bromeliads, and over fifty species of palms. This extensive collection helps to enhance this beautiful, historic twenty-acre garden.

A tour of the grounds offers visitors a chance to also see the historic homes: Edison Winter Estate—Seminole Lodge, Main House, Guest House, Caretaker's

Courtesy of O'Phelan

House, Pool Complex; Ford Winter Estate—The Mangoes; the Edison Botanic Research Laboratory; and the Estate's Museum.

The Estates Garden Shoppe uses seeds from the historic trees and propagates them until they are ready for sale. Annuals, herbs, fruit trees, butterfly plants and other varieties of landscaping plants are also for sale. Edison Ford Garden Tours are offered, and workshops and other events are held throughout the year.

All photos in this chapter are courtesy of Edison & Ford Winter Estates, unless otherwise noted.

EARLY PLANS: In March, 1885, Thomas Alva Edison visited Fort Myers for the very first time. He was impressed with the botanical growth of the area and, shortly after arriving, purchased thirteen acres of beautiful property along the Caloosahatchee River. He later built two winter homes, and a laboratory and also planted a botanical garden. Who would have thought that so many years later, the Estates would draw over 200,000 visitors and is one of the ten most visited historic sites in the country? After purchasing the property from Sam Summerlin in 1885, Edison's plans for the property were sketched on a napkin while *en route* to New Jersey. The aerial picture shows the twenty-acre estate looking down from the Caloosahatchee River.

EDISONS AND FORDS: Henry Ford and his wife, Clara, along with Thomas and Mina Edison, stand in front of the Edison Botanical Laboratory. It was built in 1927, and was operational until 1936. The lab contained a chemical processing area, machine shop, grinding room, office and dark room. It was designated as a National Historic Chemical Landmark in 2014. The nursery is to the right of the lab.

ON THE BOULEVARD: Shortly after purchasing the property, and beginning in 1906, Edison planted 200 royal palm trees along the dirt road. The palm trees stretched from his property to the downtown area of Fort Myers. Some of the towering palm trees, reaching seventy-five feet in height, still stand today, while they also mark the front gate entrance of the Edison & Ford Winter Estates.

NEAR THE MAIN GATE: There are approximately 1,800 palm trees that line McGregor Boulevard, named earlier as Riverside Avenue, and originally called Punta Rassa Cattle Trail. The street was named McGregor Boulevard after Ambrose McGregor, whose wife, Jerusha, "Tootie," worked on beautifying Fort Myers, and widening the boulevard in his honor. There are now streetlights and walkways added for the many visitors that cross from the Visitor's Center on the east side of McGregor Boulevard to the Estates located on the west side of the road.

Under the Mango trees, Edison Residence

MANGOS AND MORE: Thanks to garden lovers Thomas and Mina Edison, the Edison & Ford Winter Estates have over a dozen varieties of mangos, such as Keitt, Bailey's Marvel, Kent, and Valencia Pride, and also the old Turpentine mangos shown here. Many of his beloved mango trees were planted shortly after the property was purchased, and many still border McGregor Boulevard. A good selection of other fruits, such as citrus, lychee, star fruit and papaya, now grow as well. Large Traveler trees currently line the path.

FABULOUS FOUNTAIN:

A circular rock fountain was added towards the end of the pathway from McGregor Boulevard to the Caloosahatchee River where the Seminole Lodge dock also laid. Fishing was a favorite pastime of the Edisons and a great tarpon fishing spot was just steps away right in the Caloosahatchee River. The fountain, near the river, still stands today and is a popular spot for photographs. South of the fountain lies the Edison and Ford homes, while to the north is the Moonlight Garden, the Caretaker's House and the Pool Complex.

Courtesy of O'Phelan

65

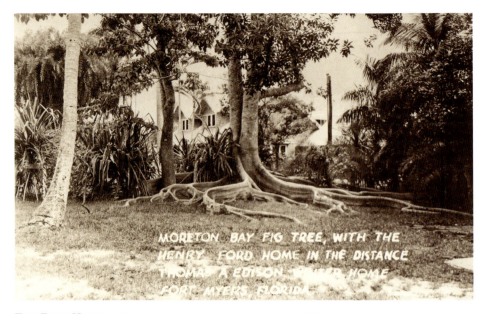

MORETON BAY FIG TREE, WITH THE
HENRY FORD HOME IN THE DISTANCE
THOMAS A EDISON WINTER HOME
FORT MYERS FLORIDA

THE FORD HOUSE: A Moreton Bay fig tree stood near the Ford Home, a craftsman-style bungalow, purchased in 1916, by Henry Ford, and located next door to Seminole Lodge, Edison's Winter Home. The Morton Bay fig was struck by lightning in the 1990s, and replanted in 2006. This type of fig, an evergreen, can reach heights of sixty feet or more and can sport a massive trunk. Most of the roots of this splendid tree are located above ground. The Ford House, with one porch facing the river and another one facing McGregor Boulevard, is now surrounded by other vegetation, including tropical fruit trees, citrus trees, royal palms, royal poincianas (often called flamboyant trees), and a massive Mysore Fig tree.

SIGNIFICANT BAMBOO: Twelve varieties of bamboo were planted on the Estates. Edison used the bamboo in his lightbulbs as a carbonized bamboo filament with a glass bulb surroundng it. Edison's original Bambusa oldhamii (timber bamboo), shown here with the Edison children and friends, still stands today. Bamboo, a member of the grass family, is one of the fastest-growing plants on Earth. Furthermore, it is a renewable resource, as canes can be harvested as new ones continue to grow.

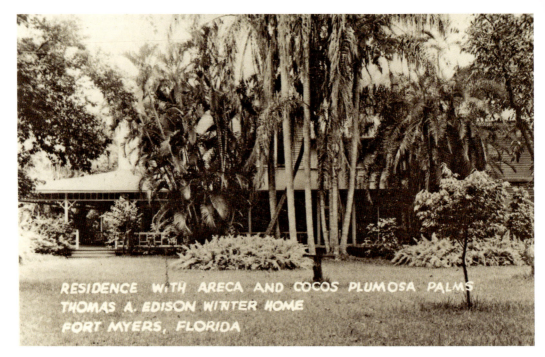

RESIDENCE WITH ARECA AND COCOS PLUMOSA PALMS
THOMAS A. EDISON WINTER HOME
FORT MYERS, FLORIDA

THE EDISON MAIN HOUSE: Thomas and Mina, who were both nature-lovers, planted an abundance of vegetation on the grounds. Outside of the Edison home, queen palms and areca palms were planted. Today, majestic palms, tropical fruit trees, and many flowering plants that butterflies and birds love, are still just steps away from the front and back porches. The porches were enjoyed by family, visitors and prominent guests who loved the beauty, the privacy and the peace offered on the porches and throughout the Estates.

THE UPKEEP: In addition to the Edison Winter Estate—Seminole Lodge—and the Ford Winter Estate—the Mangoes—there were other buildings and homes that needed to be tended to, including the Edison Caretaker's Cottage and Edison's study, just steps from the rock fountain, along with the Guest House (shown here with citrus trees), the Caretaker's House, the Pool Complex and the Edison Botanic Research Laboratory. Today, over 250 volunteers help keep the 20-acre Estates running smoothly.

Courtesy of O'Phelan

TAKING A DIP: The Pool Complex was constructed in 1910, and offered a high diving board and poolside seating. In 1928, it was remodeled and a tea and a bath house were added. The complex, now lined by potted plants, is adjacent to the Caretaker's House, and close to Mina's Moonlight Garden, the original home of an electrical laboratory where Thomas Edison worked on his bamboo light bulb.

AFTERNOON BREAK: Guests of the Estates would often enjoy afternoon tea—a time to relax and chat—under the shade of the mango trees. Mina gave many clubs and groups tours of the grounds as a way to be active in the Fort Myers community. Next to the pool is also a tearoom where Mina used to entertain guests. Today, guests enjoy lunch and drinks in the picturesque setting of the Banyan Gardens Café, located near the Garden Shoppe, the Estate's Museum, and the Edison Botanical Laboratory.

TAKING CARE: The original fountain was cement, while rocks were later added to keep it contained. The electrical laboratory was located behind the fountain, while the Caretaker's House still stands nearby the fountain in the far background. The laboratory was later disassembled and taken to Greenfield Village. The Caretaker's House is a good example of a Florida Cracker House, where early pioneers and herdsmen stayed. Dating back to the 1870s, the main section of Caretaker's House is one of the oldest standing structures in the City of Fort Myers. It was part of the original land purchase by Edison, and was used by cattle herdsmen. Today, those who tend to the Estates can find many places to take a break including at the Banyan Gardens Café, where a lofty fig tree shades the area.

INVITING PLACES: Mina's Moonlight Garden was once an electrical laboratory; however, when the lab was moved by Henry Ford to Greenfield Village, Michigan, the site became Mina's garden where she enjoyed the picturesque setting with her friends and family. Shown here is Mina Edison and the Periwinkle Garden Club enjoying the Moonlight Garden and a tour. Today, Mina's Moonlight Garden is still surrounded by flowering vegetation and attracts an array of colorful birds and butterflies, a perfect setting for pictures or a wedding.

REFLECTION PONDS: Thomas and Mina stand in their finery by Mina's Moonlight Garden that was designed in 1929 by renowned landscape architect Ellen Biddle Shipman. Today Mina's Moonlight Garden is picture perfect for photo opportunities, and small wedding ceremonies, as it surrounded by white and fragrant vegetation and boasts the original reflection pond. The original little office window overlooks the back garden.

THE REMODEL: Early on, the grounds, including Mina's Moonlight Garden with a lattice trellis, were carefully tended to. However, as time passed, the Estates were in need of a remodel. From 2007-2010, the Estates undertook a nine million dollar re-modeling effort in order to bring back Edison's Botanic Laboratory, the Seminole Lodge—Edison's home, Mina's Moonlight Garden and The Mangoes—Ford's home. Upon completion, the results were award-winning.

PASTIME PORCHES: The wide, open wooden porches on Edison's Winter Estate, the Seminole Lodge, were an inviting spot for Mina and her guests who loved to do needlework on the porches. After Thomas Edison's death in 1931, Mina wintered at Seminole Lodge until 1947, when she deeded the property to the City of Fort Myers. She died shortly after and was buried next to Thomas in New Jersey. The Edison and the Ford House, shown here, were both brought back to their original splendor after the remodeling efforts.

NAPLES BOTANICAL GARDEN

ESTABLISHED AS A BOTANICAL GARDEN IN 1993

N aples Botanical Garden, located in Naples, Florida, was established in 1993 by a group of Naples residents. What started off with just a dream of a botanical garden became a 170-acre site with seven different habitats—thanks to a gift from the Kapnick Family. In 2000, the area began its transformation into a sub-tropical botanical garden that now boasts nine cultivated gardens, two and one-half miles of walking trails, and ninety-acres of restored native preserve.

The gardens are comprised of the Marcia and L. Bates Lea Asian Garden, with many Asian wonders; the Kathleen and Scott Kapnick Brazilian Garden, including seven terrestrial ecosystems found in Brazil; the Kapnick Caribbean Garden, representing the diversity of lush mountain tropical forests, along with low islands filled with cactus and scrub; the Vicky C. And David Byron Smith Children's Garden filled with flowers, vegetables, butterflies, streams and a children's tree house; the Karen and Robert Scott Florida Garden, featuring a circular planting of Florida's State Tree, the sabal palm, along with bougainvillea and silver palmetto; and, lastly, the Water Garden, filled with water lilies, lotuses and papyri. Also on-site is the Preserve, comprised of the Vicky and David B. Smith Uplands Preserve and the Collier Enterprises South Wetlands Preserve. This ninety-acre sanctuary features habitats ranging from flooded brackish marsh to dry upland scrub. An expansion completed in October 2014, added the Eleanor and Nicholas Chabraja Visitor Center, along with three new gardens, Kathryn's Garden, Irma's Garden and the LaGrippe Orchid Garden, as well as the Garden Store and Fogg Café, operated by Lurçat Catering.

Naples Botanical Garden offers group tours, school field trips, educational opportunities, and hosts programs for those who are sight-impaired, those on the autism spectrum, and Alzheimer's patients in the Buehler Enabling Garden as horticultural therapy.

All photos in this chapter are courtesy of Naples Botanical Garden, unless otherwise noted.

THE EARLY VISION: Naples Botanical Garden came to life, thanks to a group of local plant enthusiasts. In 2000, the late Harvey Kapnick Jr. spearheaded the land deal, just three miles from Downtown Naples, and donated five million dollars for the 170 acres of open space. The location now holds nine cultivated gardens and ninety acres of preserved conservation land. The Garden has since bloomed magnificently and its notable Plumeria Collection, of over 400 varieties of plumeria, is recognized by the North American Plant Collections Consortium as the National Plumeria Collection.

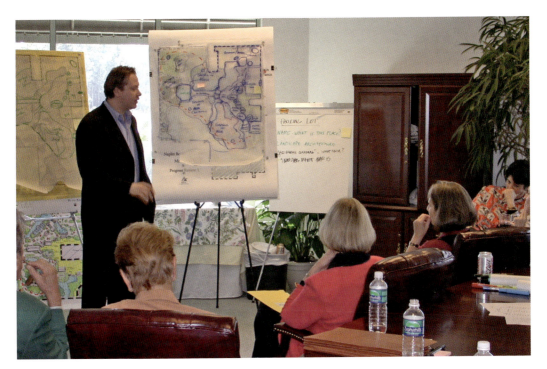

CONSERVATION EFFORTS: Once the land was purchased, almost half of it was set aside as a conservation area. Conservation areas receive protection due to their natural, ecological or cultural values. The Garden's other half now also features plants and cultures of the tropics and subtropics, such as the Cattleya violacea, while many more orchid types can be found in the LaGrippe Orchid Garden, that offers a splendid and growing assortment of orchid species and varieties.

STARTING THE TASK: In May, 2008, construction began on the property. Now there are nine cultivated gardens, two and one-half miles of walking trails, and ninety-acres of restored native preserve. There are also garden elements and structures that help define each area, such as the Nancy and Jonathan Hamill Cracker House in the Vicky C. and David Byron Smith Children's Garden. Cracker Houses are small wood-frame houses with metal roofs, raised floors and open porches, often associated with 19th Century architecture, a style specific to Florida.

MORE THAN EXPECTED: The greenery and vegetation isn't the only thing that grew. Nowadays more than 150,000 visit the gardens each year, where they see plants, wildlife and flowers, and other elements such as the colorful Chattel House. A chattel house is one that can be physically moved from location to location, and was used throughout the history of the Caribbean, particularly in Barbados. The Kapnick Caribbean Garden, where the Chattel House is located, also offers a citrus area and coconut grove.

HELP FROM OVERSEAS: While the original acreage was full of invasive plants, the designers could envision what the space could one day be. The Garden was designed and planted with species that originate from between the 26th parallels north and south. Three gardens were open to the public in 2009, the Vicky C. And David Byron Smith Children's Garden, the Kapnick Caribbean Garden and the Karen and Robert Scott Florida Garden. In late 2000, a crew of Balinese master craftsmen came to Naples to assist with the creation of the hand-crafted structures in the Marcia and L. Bates Lea Asian Garden, such as this ornate wooden Thai Riverside Pavilion, made from 10,000 pieces of wood.

TURNING IT OVER: The Garden designer's visions helped turn the land into what was to become a splendid garden. Some of the space was cleared to make way for a wildflower meadow, which is now surrounded by four rings of saw palmettos. The garden is also home to a variety of colorful native plantings. Native plants are those that either have developed, occur naturally, or may have existed many years in a certain area.

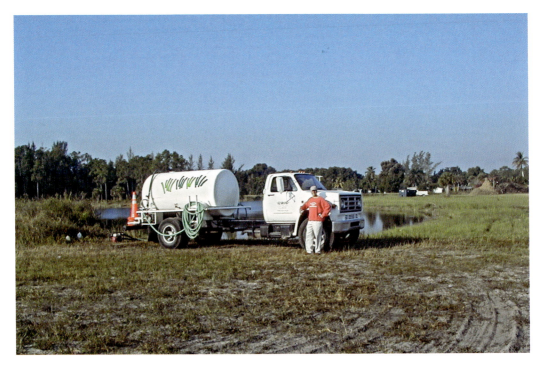

PLENTY OF H2O: These days, the Water Garden and Performance Lawn are natural focal points for performances and events. They are located right in the heart of Naples Botanical Garden. A boardwalk allows visitors to fully experience the Water Garden by offering views from both sides. It is filled with water lilies, lotuses and papyri, and is also where the musical programs are hosted. The water lilies' flowers exist on separate stalks, while the leaves float on the water's surface.

WATER EVERYWHERE: The location came with a pond that was preserved for the garden. Now water features are located throughout the Garden, particularly in the eighty cultivated acres, most spectacularly in the Kapnick Brazilian Garden where a large waterfall highlights the Burle Marx mosaic. The Kapnick Brazilian Garden is striking and markedly Brazilian, as it is in fact a tribute to Roberto Burle Marx, known internationally as the "father of modern landscape architecture." Its centerpiece is indeed the only original Burle Marx ceramic mural in the United States.

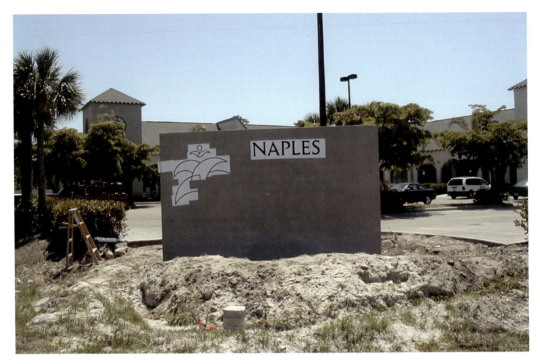

BIRD IS THE WORD: As soon as the sign went up, birds and other wildlife became even more interested in calling the Garden home. There are egrets, roseate spoonbills, herons and osprey, as well as turtles, lizards and other Florida wildlife. The James and Linda White Birding Tower, which overlooks the Preserve, was constructed to allow guests of all ages to see these incredible birds and other native creatures in action.

FLOATING FREELY: Water is crucial for all living things to thrive, and making the Garden water efficient was always part of the plan, even in the early digging days. It is almost completely self-sufficient in terms of water, due to advanced water filtration systems and the Mary and Stephen Byron Smith River of Grass. The Garden employs sustainable practices in garden designs, water use, architecture, horticulture practices, and day-to-day operations. These award-winning practices are designed to minimize the impact on native ecosystems. Water is a notable feature for beatification purposes as well. There are waterfalls and a Water Garden where colorful water lilies float freely.

EMBRACING THE ORCHIDS: By the time the front sign was installed at the garden, hours and hours of work had already gone into making the Garden become what it is today. Over 7,000 households are now members of the Garden, and that number continues to grow. One popular attraction is the array of colorful orchids and epiphytes that can be found on the grounds. The LaGrippe Orchid Garden, a recent addition, is the only public outdoor garden devoted solely to orchids and epiphytes in the continental United States.

MAKING ADDITIONS: What began as an idea back in 1993 has grown phenomenally year by year. In 2014, a $15 million dollar expansion was completed, representing phase three of the Garden's master plan. The expansion includes the 25,000-square-foot Eleanor and Nicholas Chabraja Visitor Center, along with the Fogg Café and three new gardens—the LaGrippe Orchid Garden, Kathryn's Garden, with a jungle atmosphere, and Irma's Garden, offering unique and charismatic plants. These three new gardens were all designed by renowned Miami landscape architect, Raymond Jungles, who also designed the Kapnick Brazilian Garden.

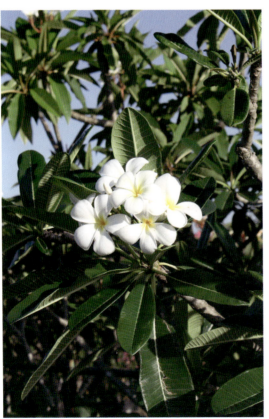

NATIVELY SPEAKING: The early plants and cuttings gave only a hint as to what the Garden would later become. Now the Garden blooms with showy orchids, flowering trees, and thousands of native plants, many of which line boardwalks and walkways at the Garden. Native plants require less water or irrigation, have lower maintenance needs, and are beneficial to local wildlife. They often offer beautiful blossoms.

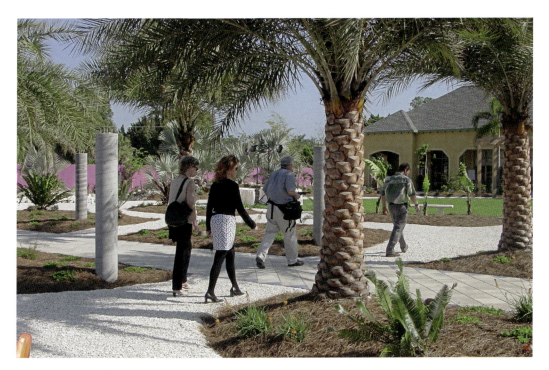

SENSE OF COMMUNITY: During the eighteen months after opening, the Garden welcomed nearly 200,000 visitors, 10,000-15,000 per month. Ever popular, the Garden offers a chance to relax and stroll, learn about wildlife and vegetation, and connect with the environment all through display, education, conservation and science. The Garden is also a community gathering place and hosts many events and exhibitions. Weddings are also popular events and the picture-perfect lawns make for a great backdrop.

WORLDWIDE NOTICE: Since the grand opening in 2009, Naples Botanical Garden has received worldwide recognition—from Canada to Germany to France to Singapore to Brazil and Indonesia. In October, 2014, the ribbons were cut to celebrate the opening of the Eleanor and Nicholas Chabraja Visitor Center, three new gardens, Kathryn's Garden, Irma's Garden and the LaGrippe Orchid Garden, as well as the Garden Store and Fogg Café.

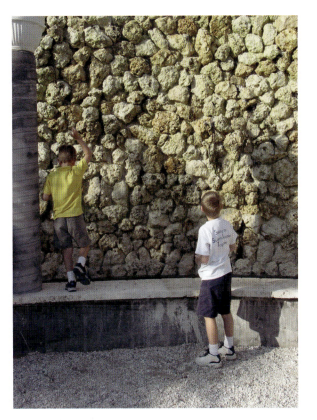

Through Children's Eyes:

Children were always a consideration in the original plans for the Garden. Now the Vicky C. and David Byron Smith Children's Garden offers flowers, vegetables, butterflies, tree houses and small, running streams. There is a Hidden Garden for children to discover fun things like flowers sprouting from household items, and Judy Herb's Herb Garden for them to learn about planting and growing, there's also the Pfeffer-Beach Butterfly House with a variety of butterflies and docent on-hand to explain more about each type.

A BRIDGE TO FRUITION: What began with an idea and a desire to create a botanical garden has bridged into an amazing reality. Naples Botanical Garden is now on many people's "must see" lists when visiting Southwest Florida. Tourists and residents alike are impressed immediately on their arrival through the Jane and Charles M. Berger Entry Pavilion.

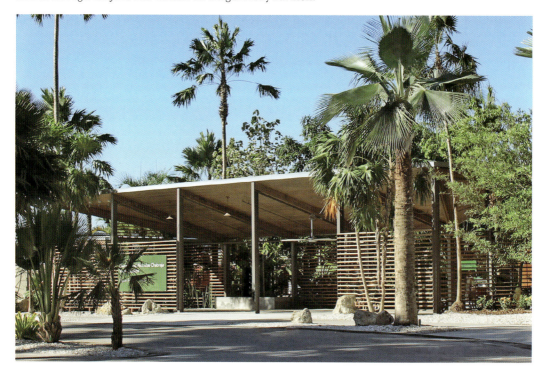

Acknowledgements

This book was made possible thanks to the generous assistance from Terry Berube, President, Florida Botanical Gardens Foundation; Larry A. Kelleher, Media Specialist, Sarasota County Historical Resources; Grace Carlson of Carlson Studio Marketing; Bruce Holst, Director of Botany, Marie Selby Botanical Gardens; the helpful folks at Marie Selby Botanical Gardens and Research Library, Lisa Sbuttoni, PR/Marketing Director and Debbie Hughes, Senior Horticulturist, Edison & Ford Winter Estates; Anita Force Marshall, Head Gardener, The Botanical Gardens at Sanibel Moorings; and Renée Waller, MA, Communications Coordinator, Naples Botanical Garden.

If You Go

FLORIDA BOTANICAL GARDENS
12520 Ulmerton Rd, Largo, FL 33774
(727) 582-2117
www.flbg.org

MARIE SELBY BOTANICAL GARDENS
811 S Palm Ave, Sarasota, FL 34236
(941) 366-5731
www.selby.org

THE BOTANICAL GARDENS AT SANIBEL MOORINGS
845 E Gulf Dr., Sanibel, FL 33957
(239) 472-4119
www.sanibelmoorings.com

EDISON AND FORD WINTER ESTATES
2350 McGregor Blvd, Fort Myers, FL 33901
(239) 334-7419
www.edisonfordwinterestates.org

NAPLES BOTANICAL GARDENS
4820 Bayshore Dr., Naples, FL 34112
(239) 643-7275
www.naplesgarden.org

Other Western Florida Botanical Gardens:

PALMA SOLA BOTANICAL PARK
9800 17th Ave NW, Bradenton, FL 34209
(941) 761-2866
www.palmasolabp.com

NATURE COAST BOTANICAL GARDEN & NURSERY
1489 Parker Ave, Spring Hill, FL 34606
(352) 683-9933
www. naturecoastgardens.com

ALFRED B. MACLAY GARDENS STATE PARK
3540 Thomasville Road, Tallahassee, FL 32309
(850) 487-4556
www.floridastateparks.org/maclaygardens

Other Botanical Gardens mentioned:

KEW GARDENS
Royal Botanic Gardens,
Kew Richmond,
Surrey
TW9 3AB
020 8332 5655
www.kew.org

MISSOURI BOTANICAL GARDEN
4344 Shaw Blvd., St. Louis, MO 63110
(314) 577-5100
www.missouribotanicalgarden.org

UNITED STATES BOTANIC GARDEN
100 Maryland Ave SW, Washington, DC 20024
(202) 225-8333
www.usbg.gov